MW01001308

DAILY DOODLE JOURNAL

DAILY DOODLE JOURNAL

365 Days of Creative Prompts
Discover Your Inner Whimsy and Find
Moments of Mindfulness

ROCKRIDGE
PRESS

Copyright © 2021 by Rockridge Press, Emeryville, California

No part of this publication may be reproduced, stored in a retrieval system, or transmitted in any form or by any means, electronic, mechanical, photocopying, recording, scanning, or otherwise, except as permitted under Sections 107 or 108 of the 1976 United States Copyright Act, without the prior written permission of the Publisher. Requests to the Publisher for permission should be addressed to the Permissions Department, Rockridge Press, 6005 Shellmound Street, Suite 175, Emeryville, CA 94608.

Limit of Liability/Disclaimer of Warranty: The Publisher and the author make no representations or warranties with respect to the accuracy or completeness of the contents of this work and specifically disclaim all warranties, including without limitation warranties of fitness for a particular purpose. No warranty may be created or extended by sales or promotional materials. The advice and strategies contained herein may not be suitable for every situation. This work is sold with the understanding that the Publisher is not engaged in rendering medical, legal, or other professional advice or services. If professional assistance is required, the services of a competent professional person should be sought. Neither the Publisher nor the author shall be liable for damages arising herefrom. The fact that an individual, organization, or website is referred to in this work as a citation and/or potential source of further information does not mean that the author or the Publisher endorses the information the individual, organization, or website may provide or recommendations they/it may make. Further, readers should be aware that websites listed in this work may have changed or disappeared between when this work was written and when it is read.

For general information on our other products and services or to obtain technical support, please contact our Customer Care Department within the United States at (866) 744-2665, or outside the United States at (510) 253-0500.

Rockridge Press publishes its books in a variety of electronic and print formats. Some content that appears in print may not be available in electronic books, and vice versa.

TRADEMARKS: Rockridge Press and the Rockridge Press logo are trademarks or registered trademarks of Callisto Media Inc. and/or its affiliates, in the United States and other countries, and may not be used without written permission. All other trademarks are the property of their respective owners. Rockridge Press is not associated with any product or vendor mentioned in this book.

Interior and Cover Designer: Mando Daniel
Art Producer: Samantha Ulban
Editor: Eun H. Jeong
Production Editor: Emily Sheehan
Production Manager: Jose Olivera

Illustrations © 2021 Collaborate Agency

Paperback ISBN: 978-1-63807-084-9
R0

THIS JOURNAL BELONGS TO:

INTRODUCTION

Welcome to your year of doodling, creativity, and calm.

Within these pages you'll find 365 prompts—one for each day of a year—to start you off on a doodle task. Of course, you don't have to follow the prompts exactly—who's going to know?—but each one will give you an idea to doodle and devote around 10 minutes a day to yourself. Art is a great way to express emotions—both joyous and difficult—by helping you process them and release them. You will also find it helps unlock the creativity inside you to develop your drawing skill or just help you along your journey of self-discovery and personal growth.

You may have picked up this journal because you often find yourself doodling during a task and you're wondering if you are not paying attention. This isn't the case. Studies have shown that doodling can help you retain more information, concentrate better, and tap into the creative part of the brain, which means problem-solving becomes easier, too. By relaxing the mind as you often can during doodling, you are able to focus on the big picture rather than overthinking the details. Doodling is not only great for concentration, it can also help you find inspiration.

Doodling can also help reduce stress levels. The effects of spending a short time away from the mental load and busyness of life to focus on one, singular task can reduce anxiety and heighten well-being. It's called mindfulness, and you may find that doodling

helps you unwind from a long day and find moments of peace and calm.

As you doodle, don't worry about creating a perfect piece of finished art (though, if you get something beautiful out of it, that's a bonus!). It's about tapping into the right hemisphere of your brain—that's the creative side—and seeing what you can find there. And like any type of exercise, the more you do it, the better you become. So, whether you already like to spend time creating art or consider yourself a total art novice, this journal will lead you down a year-long path to creativity.

Are you ready? Have fun, get creative, and start doodling!

HOW TO USE THIS BOOK

The joy of doodling is that it should be simple and easy to pick up and do—no preparation necessary. The doodle prompts in this book require no more than a pen or pencil for you to complete. If you want to add an extra layer of mindful fun and creativity, you can use colored pens and pencils, as well, but they're absolutely not essential.

This book is for doodling, not extensive art. Don't feel you need to spend money on expensive pens and equipment. But if that's a treat for you, then go for it!

Pens range from very cheap to very expensive. They come in different thicknesses, and depending on the thickness of the pen, you will get a different effect.

Pencils, too, range in price and in hardness of the lead. The hardness is based on a scale—the higher the number, the harder the graphite. The most commonly used number is 2. A number 2 pencil is equivalent to an HB (or "Hard Black") pencil outside of the United States.

Try out different effects with different pencils of varying hardness. The higher the number, the more lightly it marks the paper. Softer pencils leave darker marks, and they need to be sharpened more often.

Whatever tool you choose to doodle with, if you make a mistake, know that you can just doodle right over it and see where that mistake takes you. Remember, just have fun and let the doodling inspire you!

TREE TUNES

Add musical notes above these chirping birds. Take a moment to enjoy the melody you've made.

CUSTOM CLASSIC

Design this sneaker. Do you go along with what's trending or set your own style?

SOUVENIR STICKERS

Cover this suitcase in stickers. Will they show where you've been . . . or where you'd like to go?

ALL THE FEELS

What kind of week have you had? Fill in these blank emojis with some of your recent emotions.

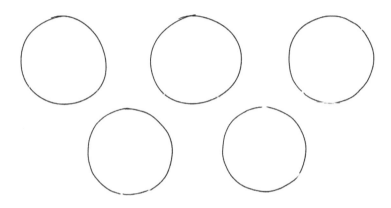

WISH UPON A STAR

Fill this space with shooting stars. Make a wish!

COSTUME PARTY

It's party time! This person needs a costume. Maybe they're wearing a costume you've worn before, or you could invent something new.

180 KICKFLIP

Add a gnarly design to this skateboard to impress the cool kids.

PARTY FROM THE PAST

What kind of themed party would you love? Decorate this hat to fit that theme.

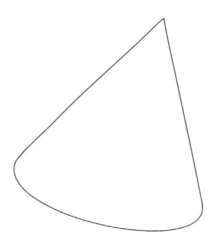

DON'T BE NERVOUS; JUST BE YOURSELF

Give this interviewee a snazzy tie for their meeting.

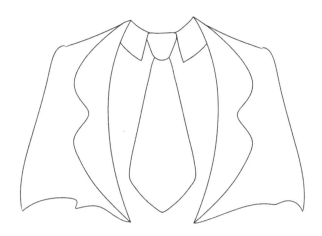

SKY MESSAGE

If you could surprise someone with a message in the sky, what would it say?

MONSTER MANIA

Draw the monster you wish lived under your bed!

HOOK, LINE, AND SINKER

You've got quite a haul, there! What did you manage to catch?

A PEACEFUL POND

Doodle some fish calmly swimming in this pond. Even small spaces can bring comfort.

A CREST OF YOUR OWN

Design a family crest to represent the strengths and history of the "house" you belong to.

GOLDEN AND DELICIOUS

These pies are nearly done—they just need you to add the crusts! Yummy!

YOU SLAY!

Design a powerful magical sword so you can slay your fearsome foes!

AND THE KITCHEN SINK?

Add challenging objects for this juggler to toss. Don't worry; they're a professional!

WALKIES

What's your idea of the perfect pup? Imagine what a walk with it would be like.

RUSTLING CATTAILS

Give this pond some reeds waving in a brisk breeze. Will you draw them with or without their seeds on?

WHEN THE TIDE COMES IN

Fill this beach with beautiful seashells. Make sure to draw your favorite kind!

LOVE POTION NUMBER 1

Throw in the ingredients for a love potion designed to work on you.

HOLD ON TIGHT!

Doodle your dream crane-game prize. You have it in the claw now, but will it stay?

WHAT'S UP? (FROM THE DEEP)

Draw a sea monster rising up. Is it nice or nasty?

SHOCK! HORROR!

Doodle on this pumpkin to give it a face. Will you carve something whimsical or spooky?

NEIGHBORHOOD MURAL

Design a mural you'd love to see from your window.

CAN'T SEE THE WOODS?

Celebrate the outdoors by filling this forest scene with trees.

WHO'S THIS FUN GUY?

Add some mushrooms and toadstools to this woodland scene. Will you give them a down-to-earth look or make them fun guys?

GROWING UP

Nowhere to grow but up! Draw a welcoming garden or crawling vines for this apartment building.

A STAR IS BORN

Draw a character around this constellation and give it a name. What's its origin story?

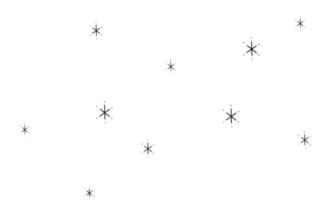

SUPER SUB

Doodle the ingredients of the ultimate party sub. Do you prefer pickles on the side?

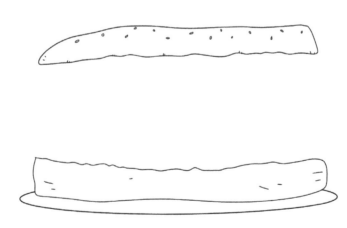

A STRING OF LIGHTS

Plug in some fancy-shaped lightbulbs to these string lights. Stars, hearts, lanterns … What shapes will you pick?

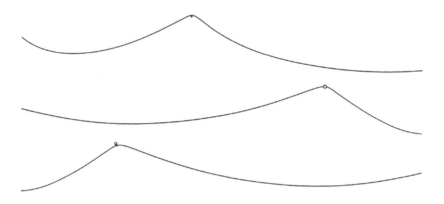

PAW PRINTS

Two naughty cats have gotten into a place they shouldn't be! Doodle the pawprints they've left in this cement.

LIGHTNING STRIKE!

Create some ominous storm clouds, then bring the lightning!

MAGICAL CRYSTALS

Complete this crystal, then add some more. Are they natural, magical, or other-worldly?

CLOUD CRAFTING

Have you ever gone cloud-watching? Fill this sky with clouds in shapes you wish you'd find.

HOME JUNGLE

It might be a jungle out there, but it's one in here, too! Fill these pots with plants to create a wild vibe.

BRUSHES UP NICELY

You've picked up a brand-new hairbrush! Draw in its shiny new bristles.

ABRACADABRA

Draw a spell emerging from this magician's wand and decide what its effect would be.

ALL WOUND UP

Doodle in some bunches of yarn balled into different shapes.

CEREAL HERO

Cereal needs something fresh, a drastic change . . . a new hero! Design the next, great cereal mascot!

DAISY CHAIN

Join in on this daisy chain and help complete it. Not every daisy needs to look the same!

WATERY HOME

This fish tank is ready for some residents! Draw in some aquatic pets living it up.

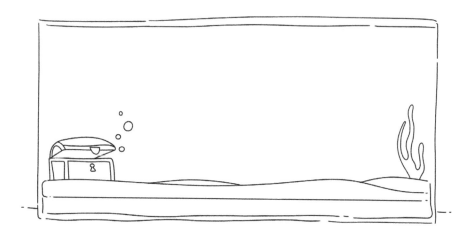

SUPER SOUP

Fill this pot with your favorite homemade soup. What ingredients are key to the recipe?

READING LIST

Fill the first shelf with your favorite books, then add some you'd like to read to the second.

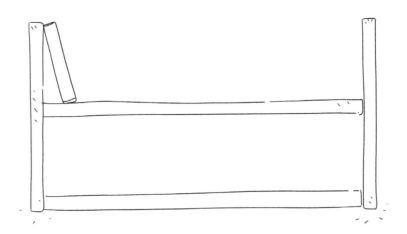

SUPER-POWERED

The commissioner is calling upon the city's hero! Design their heroic signal to light up the night sky!

YOU'RE IN CONTROL

There's debate over which is the best game controller. Design one that would be ideal for you.

A CUT ABOVE

Give these party guests some fancy hairdos! Are these styles for work or play?

CAT NAPPING

Where has this sleepy kitten decided to settle down for a nap? Probably somewhere it shouldn't be . . .

DIY DISASTER!

Their chair turned out perfectly. Yours, however, looks different. Is it even a chair? Draw your finished product.

SPOTS OR STRIPES?

These cats might look identical, but by doodling different patterns on their coats, you'll be able to tell them apart.

FLOATING BY

Design a float for a parade you'd love to be in. Don't forget to smile and wave!

NO WISHING FOR MORE WISHES!

Draw a genie emerging from the lamp, ready to grant your three wishes. Write them down here, or doodle in some wish bubbles, instead, if you like.

SWEET TREAT

Add a candy pop to this stick. Is it a classic, or something out of this world?

T-SHIRT DESIGN

Invent the name of a band you'd like to be in and design a T-shirt for it!

GLAZING OVER

Decorate these donuts with some flavors you'd love to see—and taste.

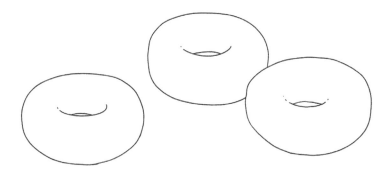

SPECTACULAR SNACKS!

Pretzels can come in all sorts of shapes. Try doodling them with a new twist!

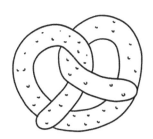

HIGH TEA

This tea set needs a delicate touch to feel complete. Give it something personal.

POTION PEDDLER

Potion seller, give me your strongest potions. Doodle in the most powerful brews.

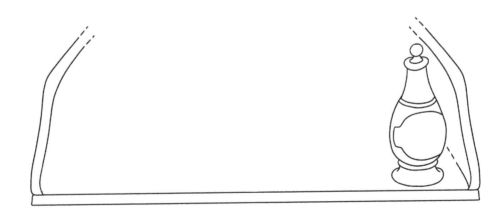

PUPPET SHOW

Draw a puppet attached to these strings. Is it a happy dancer, a prankster, or something else?

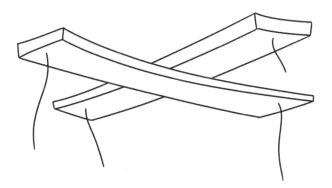

COMING OUT OF OUR SHELL

Shell surfing might be fun, but these sea turtles could use some heads and flippers doodled on.

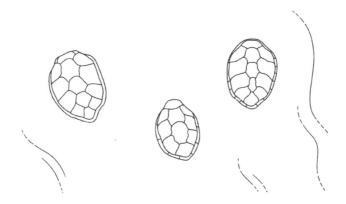

SHAKE YOUR TAIL FEATHER

They're dressing to impress. Give this proud bird a magnificent display of plumage!

YOU WAG!

Doodle different types of tails on these dogs as they go on a merry walk.

MADE IT . . . BY A WHISKER

These cats are ready to make some mischief. Draw in playful sets of whiskers and send them on their way.

HIGH FLYER

Who—or what—is swinging on this trapeze? What kind of trick are they performing?

I <3 YOU

Think about someone who means a lot to you. Draw some symbols in this space that express your love for them.

TIERS OF CELEBRATION!

Decorate this multilayered cake. What occasion was it made for?

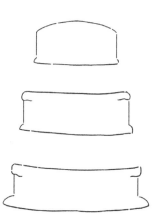

CANDLESTICKS

Add some candles and flames. Have some been lit longer than others?

HUNGRY BUGS

What's been nibbling these leaves? Draw the critters responsible for this!

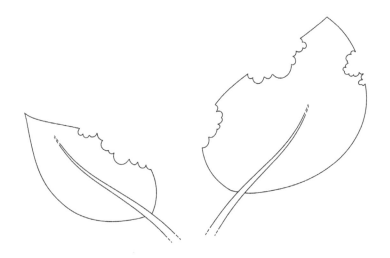

MAP MAKING

Try drawing a treasure map using landmarks around your neighborhood!

PICNIC TIME

Imagine these ants are the strongest in the world! What foods are they taking home?

BEAUTIFUL BILLS

Draw fantastic beaks on these tropical birds so they're ready to take flight.

FLIGHT PATTERN

Draw wings for these butterflies, decorating them with symmetrical patterns.

PINS AND PATCHES

Decorate this backpack with badges and patches that say something about the owner.

HEADPHONE MASTERPIECES

Draw a pair of headphones for each person. What kinds of music are they listening to?

PUMP UP THE VOLUME

Doodle sounds and musical effects that would go along with your favorite tune.

TUBULAR!

Design an amazing new water slide. Does it meet safety standards ...?

FLOWERED UP

Add flowers to these stems that would make bees delighted to visit.

CAMPING OUT

Set up your favorite kind of tent at this campsite. Don't forget to bring s'mores!

SALMON LEAPING

This salmon is making a strong effort. Support its struggle by drawing its scales.

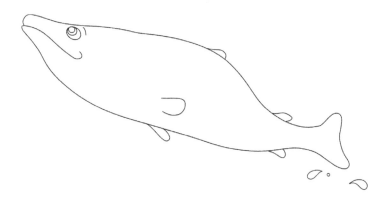

ROBO-OCTOPUS

This robot has eight clever tentacles! Decorate or equip each arm to serve its grand purpose.

SNACK ATTACK

What if your favorite snack food . . . came alive? Doodle it below to show what kind of personality it would have.

PLAIN CHEESE?

This plain pizza is just asking to be covered with toppings. Give it a flavor you haven't tried before!

TOP OF THEIR GAME

Draw stilts to keep these acrobats aloft!

SUNKEN TREASURE

Doodle some unexpected loot you might find on the ocean floor.

JEEPERS PEEPERS

Try your hand at designing different styles of eyeglasses. Give them unique frames and shapes.

S'MORE OR LESS

These marshmallows won't toast themselves! Add some flames to this campfire.

CHARM NECKLACE

Design yourself a necklace, adding some charms that have personal meaning to you.

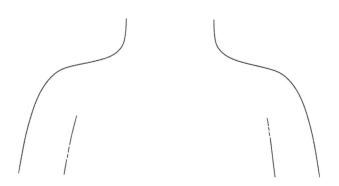

FOR THE CROWN!

You're next in the royal line to take the throne! Design a crown befitting your status.

AUTUMN LEAVES

Fill this space with drifting leaves being carried on the wind.

BALANCING ACT

Add some unusual objects to this acrobatic stunt. Give them a good challenge—they know what they're doing!

THE LAST STRAW

Draw a goofy, over-the-top novelty straw from this milkshake to its eager owner's mouth!

NESTING TIME

Fill this nest with eggs! What kind of creature(s) laid them? Are any of them hatching?

GALLERY OF THE SELF

Fill the frames of this gallery with images that reflect you as a person.

THE RIGHT KEY

Where there is a lock, there must be a key to match! Add keys of any sort you like to this ring.

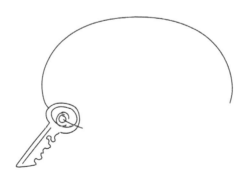

ARTIFICIAL INTELLIGENCE

Dip your toes into the world of robotics by giving these AI friends some heads.

DOODLE A POODLE!

This proud poodle won first place! As its groomer, give it an award-winning haircut.

MUG SHOTS

What slogan would let everyone know that this was your coffee mug?
Create one for yourself and two as gifts for your friends!

A NEW STAR

Explore a new frontier as you doodle out your own little solar system:
planets, moons, meteorites, etc.

FUNNY FACE

The circus is in town, and it's up to you to give this performer their mask and wig!

GOOD SPIRITS

What kind of imaginary drink would you love to try? Design some labels for these bottles. Try otherworldly flavors.

FEELING THE RUSH

Try doodling some water flowing down this river. Have you ever gone thrill chasing? What sorts of adventures have you gone on that made you feel more alive?

THE VISITORS

Aliens have decided to take a tour on Earth! Design a vehicle they might use on vacation while visiting us.

BEHIND BARS?

A fantastic beast has broken loose! Is it friendly, cranky, or fierce?

A LOVELY FROLIC

Doodle a person or creature having a jolly prance through this field.

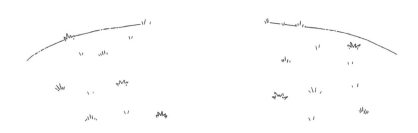

TEA FOR TWO?

Something has made a nest in this teapot! Doodle in the new resident.

WEEPING WILLOW

Give this willow tree the rest of its branches and leaves. Is it peaceful, pleasant, or angry?

WICKED VAN

Doodle a design on the side of this van that's totally vibin', dude.

OUT TO DRY

Draw some laundry hanging on this clothesline.

SQUIRRELED AWAY

Fill these trees with a stash of goodies for this squirrel to enjoy over the winter.

MUSIC MACHINE

If you ordered a new guitar, how would you decorate it? Try designing a decal for the guitar and choose a song you'd cover.

HEIRLOOMS

Imagine you've found an old tin in an attic that belonged to your ancestor. Draw what you think you'd find inside.

LUNAR LANDING

Depict your own "small step" or "giant leap" and draw a rocket landing on the moon.

LETTING YOUR HAIR DOWN!

Rapunzel's hair is so long, she needs your help getting it out the window. Doodle her hair hanging down so that someone can climb up!

JURASSIC LANDSCAPE

Doodle in the shape of a dinosaur here! Terrifying, intimidating, friendly, or gentle . . . What kind of dinosaur do you prefer?

WRITING HOME

You've gone on a vacation to a strange place. Doodle the postcard you'd send home.

NIGHT SKY

Fill this night sky with stars. What phase is the moon in? Or does it have a face?

FLY TRAP

Design a monstrous plant growing in this pot. Maybe it's hungry for flies?

HANGING AROUND

Doodle a creature, real or imaginary, hanging from this tree. Is it using its tail, claws, or paws?

ILLUMINATING!

Light up this room by drawing a lamp with an unusual shape.

TEST YOUR STRENGTH

They're hitting it with all they've got! Do the same with your drawing and illustrate a powerful ring from the bell as the ball strikes it. You might want to fill in the background with more amusement-filled tents!

WOBBLY STREET

This whole neighborhood is made of gelatin! Draw in some wibbly-wobbly houses.

DEEP BREATHS

Fill this space with balloons of all shapes and sizes! It would take a lot of hot air to fill them all, huh?

MER . . . WHAT?!

Invent a sea creature and draw it swimming here.

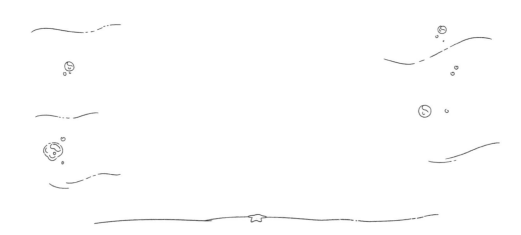

AS GOOD AS NEW!

Add merchandise to these thrift store shelves. How much is each product selling for?

SPLAT!

Draw in a ton of "splat" effects! Imagine splattering paint and the kind of shapes it makes.

PENGUIN PALS

Draw a penguin for each friend you spoke to today. Add a penguin for each friend you hope to speak to tomorrow!

A FRIENDLY BUNCH

Think of people who mean a lot to you. Add a flower to this window box for each one.

OUT IN THE WILD

Doodle the wilderness surrounding this log cabin. What makes a camping site memorable to you? Maybe a hammock or a fire pit?

LIKE PEAS IN A POD

Fill these pods up with garden peas. Give them little faces if you want to add some cartoon life to them.

ACROBAAAAAATS!

Doodle the outfit for this trained elephant doing its balancing act.

NUTS AND BOLTS

Someone's doing some tinkering, and they could use your help doodling some tools, nuts, bolts, and parts.

BREAKING THE WAVES

Draw some dolphins joining their friend and leaping happily through the waves.

HUNGRY PANDA

This panda is ready to chow down! Give it a nice big bamboo snack and surrounding forest to sink its teeth into.

FEATHERED FRIENDS

Doodle in some feathery pals hanging out at this birdbath.

SHIPS OF THE DESERT

Complete this caravan by drawing in more camel companions.

FITS LIKE A GLOVE

Draw the matching pair for each of these gloves. Remember to make sure that one is for the left hand and the other, for the right!

A WEB OF YOUR OWN

This spider's been slacking off! Draw in a web so it has somewhere to continue relaxing.

NIGHT LIGHT

This lantern is the perfect spot to draw some moths gathering.

YOUR BIGGEST FANS

Decorate these two folding fans so they look like a themed or matching pair.

WASHING UP ... AND UP!

This busser has their hands full, and you're only going to add a big stack of dirty dishes for them to clean.

A LITTLE SHELLFISH

This hermit crab wants a new home. Draw something on its back that would provide good shelter.

STORM AT SEA

Sun-tanning time is over! Scribble a storm over this coastal scene.

THE PERFECT PLANE

Fill this space with doodles of paper airplanes. Try folding one yourself!

ROBO . . .

Build a friendly robot! Any kind will do, so long as it could make a good companion.

A REFLECTIVE MOOD

Doodle a simple self-portrait in this mirror. Give the reflection an expression that would cheer you up if you saw it in the looking glass.

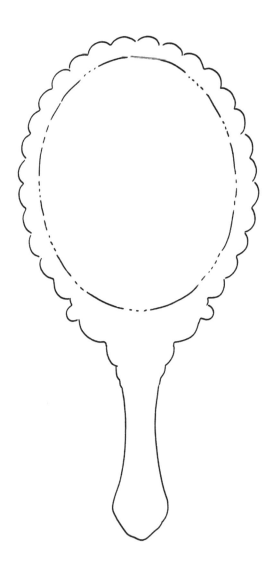

HUNGRY MICE

Draw a giant piece of cheese for these poor critters to feast on.

PAPER CHAIN

Complete this chain of paper people. Try decorating them to resemble people you know!

TOP HAT AND TAILS?

These elephants are eager to go to the ball. Give them some fancy hats!

DRAGON FLIGHT

This young dragon needs help so it can soar. Draw a cool pair of wings to get it going.

HUMAN CANNONBALL

Doodle someone you know being fired out of this circus cannon! Are they excited?

BUBBLING UP

Take a doodle-y bubble bath and fill this area with bubbles of various shapes and sizes.

A BUMPY RIDE!

Design a playground slide that would have blown you away as a kid.

A BRAVE KNIGHT

Draw a special steed for this bold knight to ride upon—it doesn't need to be a horse!

BEAUTIFUL LYRICS

Think of a line from a favorite song. Try doodling it here in a style that matches the music.

HIGH WIRE

Draw something unexpected and amusing balancing on this wire as best it can.

SLEEPING SERPENT

Fill up this space with a snoozing serpent. Is it curled, coiled, or lazily spread out?

SNOW GLOBE

Give this snow globe a little scene inside. Is it somewhere you've been before?

CASTAWAY

Draw something you'd want to see floating toward a deserted island if you were stuck there.

HEY, SUNSHINE!

Complete this row of sunflowers in any style you like, so long as it uplifts your spirit.

ON THE LOOM

Complete this rug. Will you continue the pattern, or make it evolve into something else?

THE OPEN WAVES

Doodle in lines to fill this ocean space and make some waves.

HALF MAGIC

What kind of magic is this? Conjure up this magician's other half.

FLYING THE FLAG

Add flags to these flagpoles, with one being a happy flag and the other, a sad one.

I CAN HEAR THE COGS TURNING

Complete this machine by drawing in cogs and gears. How complicated can you make it?

MOUNTAIN RANGE

Draw in a mountain range here. What's the name of the tallest peak?

SPECTACULAR STUNT

Doodle someone or something soaring through the air over this canyon. Do you think they'll make it?

YOUR INITIAL CHARACTERS

Draw your initials but make them little characters. Are they peas in a pod or did opposites attract?

I CAN SEE YOUR HOUSE FROM HERE!

Fill this sky with hot-air balloons. Are they celebrating something in particular?

JUMPING FOR JOY!

Add a whole handful of jumping beans. How high will they go?

SCARECROW

Design a scarecrow to keep the birds off this farmer's crops.

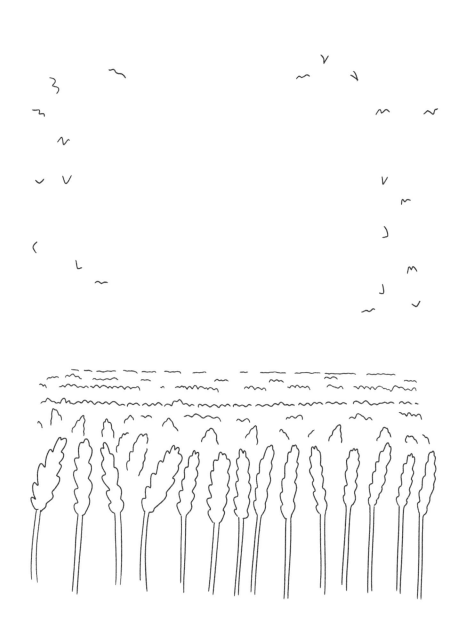

A PERFECT PAIR

Give this person some fancy new footwear! Is the footwear for comfort, sports, or work? Hopefully it's comfortable!

HOW DID THAT GET UP THERE?

Looks like something—or someone—got stuck in this tree! Draw them in before you help them down.

FULL MOON

Doodle craters onto the surface of this moon. Does it look as if it has a face?

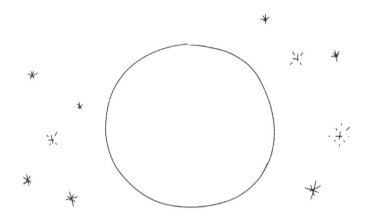

SLIP AND SLIDE

Ever been ice-skating? Trace out the tracks the skater has made in the ice.

RHYTHMIC PATTERNS

Decorate this drum with a fun pattern. Try to listen to a nice beat while you draw.

FROZEN FRIEND

Dress this snow person up so they'd be proud to stand guard by your house.

STATIC ELECTRICITY!

This kid has been rubbing a balloon over their head! Electrify their hair by doodling it in.

ADDING DEPTH

Turn these squares into cubes. Try adding different styles of shading to each, and include as many as you like.

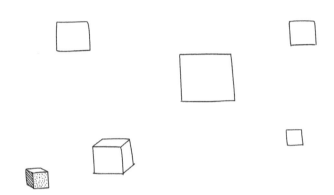

THANKS A BUNCH!

Add some grape bunches to this vine. Do you have a favorite way to eat grapes?

KISSES AND HUGS

Using only Xs and Os of different sizes and styles, try writing the name of someone you love.

SNAIL RACING

Decorate these snails' shells so they're ready to race! Which one do you think will win?

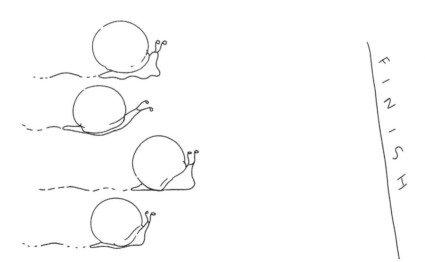

KEEPY UPPY!

Draw in some balls being juggled up and around.

PRICKLES PLEASE

These cacti aren't looking prickly enough. Give them some nice needles!

KITE-EATING TREE

This tree's been hungry! Draw in all of the kites it's managed to grab.

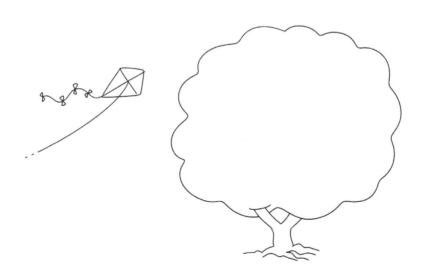

WORLD'S GREATEST BEARD

Doodle facial hair onto these faces entering a beard competition.
Which one would you vote for?

ICY TREATS

Fill these cones with ice cream and extras, but don't get too greedy.
You wouldn't want to spill!

HARVEST TIME

Complete this field of wheat stalks and imagine what you'd bake with it all!

SO ATTRACTIVE!

Doodle a chain of paper clips attached to this magnet. How long a chain can you make?

GEMSTONES

This jeweler's display needs some new merchandise. Give them the goods by doodling in valuable gems and jewelry.

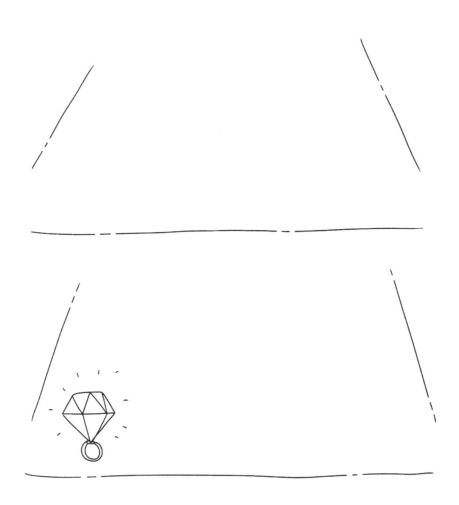

A SIDE ORDER

"Can I get some fries with that? Yeah, the doodled-in kind, please."

SMOKE SIGNALS

Draw some gentle puffs of smoke rising from this campfire, and remember to take it easy today.

PAPARAZZI

There they are! Make sure to get this celebrity's good side by drawing some snazzy camera flashes.

EGG-CELLENT WORK!

Doodle some expressive faces onto these boiled eggs. How are they feeling? You can also try out different designs instead of faces.

ZIG AND ZAG

Fill this space with zigzag patterns, adding different effects and patterns between the lines.

LIFE IS LIKE A BOX OF CHOCOLATES

Stuff this box with luxury chocolates. How many different flavors would satisfy your taste? What pattern would you place them in for maximum effect?

A NEW REALM

One does not simply forget where the mountains lie! Add mountain ranges and other landmarks to this map.

THE SUN AND THE RAIN

Add a rainbow to this landscape. You could color it in, use shading, or even try different patterns for each stripe.

HUMMING A HAPPY TUNE

There's not enough to go around! Add more flowers to this scene so every hummingbird stays happy.

SIGN YOUR NAME

Fill up this space by trying to sign your name differently from the way you usually do.

GO WITH THE FLOW

Doodle lines in this stream to show how the water is moving. What direction is it going in, and how fast?

CATCHING SOME RAYS

Try transforming this simple circle into a bodacious sun with radical rays of light beaming from it.

Z IS FOR . . . ?

Add some stripes to these zebras. You can keep it natural or go wild!

KEEPING THE RAIN OFF

Draw an umbrella here with a fun design to keep your spirits up through the rain.

LIFE'S A BEACH

Ever gone sunbathing? Or needed to dry off after a dip in the sea? Give this towel a design fit for a beach vacation.

TICKETS PLEASE!

Doodle some railroad cars onto this old-fashioned steam train. You can also add smoke rising from the engine's chimney.

SNOWBALL FIGHT!

Join in on the freezing fun by drawing in stockpiles of snowballs and snow forts for each kid.

COUNTING SPOTS

Give these ladybug wings some lucky spots. Hopefully, some of that luck rubs off on you today!

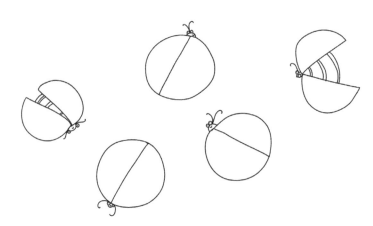

ONE LAST FORKFUL

What was something you hated eating when you were younger, but enjoy now? Add some leftovers to this plate.

FULL HOUSE

These cards look unfinished! Add the correct number of symbols so they're ready to be played. You can also draw in additional cards for a winning hand!

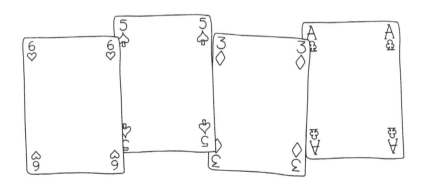

WHAT GOES UP

This elephant has catapulted something off the seesaw. Draw the object that is flying up and away.

TROMP-A-MA-PHONE!

Complete this instrument to create something that would make a new kind of sound!

A POOR SHOT

Add some arrows to this archery scene. Did any of them hit their marks?

ARMOR-PLATED

This poor dinosaur needs some protection! Give it a doodled-in set of scaly or spiky armor.

TEA FOR ONE

Complete the pattern on the side of this teacup, and feel free to add a matching saucer below it!

SO SHINY!

Fill the magpies' nest with a tiny treasure trove of shiny objects they've collected.

FEELING PUMPED

Add some GIANT wheels to this bicycle so it's ready for the BIG leagues!

A LITTLE SHADE

Draw some shady palm trees or anything else you think can provide shade to help keep this vacation spot cool.

JET STREAM

Try imagining the air moving around a plane in flight and draw how it might look here.

DON'T TAKE THE STAIRS!

Add a fancy staircase between the ground and the balcony.

ZERO GRAVITY

Draw some objects floating around on this space station. Are they astronaut supplies, or did something else get mixed in?

BLOWING IN THE WIND

Give this cyclist some windswept hair blowing behind them in the breeze.

WRAPPING IT UP

These gifts are ready to be delivered! Decorate them with ribbons and patterned paper.

WHERE DO THEY ALL END UP?

Fill this space with doodles of all the socks that have gone missing on you.

A TOAST OR TWO

Flat champagne simply will not do for this soirée! Add some bubbles to this bubbly, and make it classy.

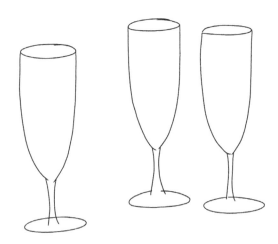

CHECKMATE

Add some faces to these chess pieces, giving each its own personality.

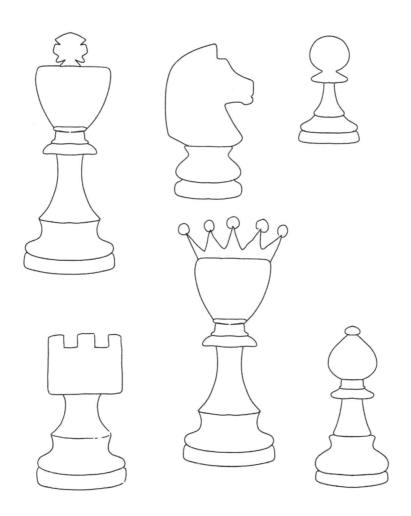

JUST TRIANGLES!

What can you draw using only triangles? An entire scene, a single character, a room? Give it a try.

BATS IN THE BELFRY

Bats can be friendly or spooky. Draw some hanging out here, and try to show both their cute and scary sides.

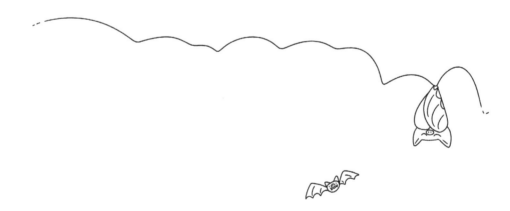

LOOP-THE-LOOP

Add a smoke trail to this stunt plane. Has it been doing tricks, writing a message, or drawing something?

PARTY DECORATIONS

You're on prep duty for the party! Draw bunting banner flags and add patterns to them!

WAY UP HIGH

Put yourself on cloud nine by doodling in some high-flying birds and relaxing clouds.

FLOCKING TOGETHER

Decorate these paragliders with a fun, matching theme.

YEE-HAW!

Draw a lasso for this cowboy. Is he a wrangler . . . or a tangler?

PIGS MIGHT FLY

Give this pig some wings. Try adding some soaring swine friends beside it!

HAVEN'T YOU "HERD"?

Doodle various patterns onto this herd of cows. Give them names while you're at it.

SWEET TOOTH

Treat yourself by filling this bag up with your favorite candy, doodle-size.

ONE AT A TIME

This eager chef is trying to flip ten pancakes at once! Doodle them in the air. You can draw waffles if you prefer.

AVIARY AIDE

Draw some sets of wings as a creative exercise. Go wild with different kinds!

EXTRA TERRESTRIAL

You have a visitor, but they're not from around here! Draw their face (or faces?) greeting you.

WATERING CAN

Doodle the drops of water pouring from this can, and feel free to doodle in some thirsty plants, too, if you wish!

ALL AT SEA

Give this cozy seaside scene some simple sailboats.

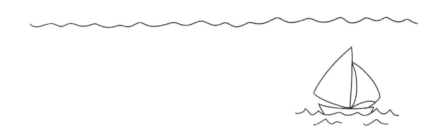

BRIGHT IDEAS

Add some thoughtful faces to these lightbulbs as they brainstorm ideas. Are they competing or working together?

A SLIPPERY CUSTOMER

This lucky monkey has stumbled into a stash! Give them enough doodle-flavored bananas to last a lifetime.

THE GRAND FINALE!

Light up this sky with the end of a fireworks show. Try different types of marks and lines for various effects.

SWEET AND SOUR

Try showing the smells coming from these two fresh dishes by drawing them in.

A MIDNIGHT STROLL

This cat is taking a walk in the moonlight. Add in another feline companion silhouette, and maybe draw in the slates of the rooftop, if you want.

THINGS ON SPRINGS

Try sticking some things on springs! Anything will do! You can give them wacky faces to show some personality.

FASTER THAN A SPEEDING BULLET

Draw another pair of rocket boots beside this one. Customize them to fit your taste!

A FEW MORE STICKS

This busy beaver could use some help finishing its dam. Even doodled-in sticks would be sturdy enough!

BIRTHDATE

Draw the numbers of your birth date (month, day, year) as candles on top of this cake. Make a wish and include something to remind you what you wished for.

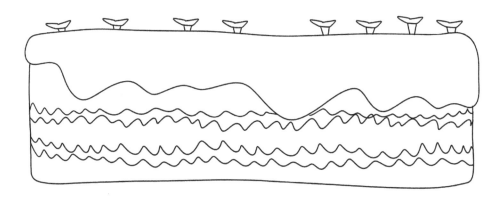

CRAFTY CANOE

Decorate the side of this canoe. Is this a boat someone uses for sport, for fun, or as their job?

RAINY SEASON

Make it rain for this dry, dry scene. What kind of desert-dwellers would appreciate it the most?

BUZZING IN THE TREES

This bee can't do everything alone! Draw in some fellow workers buzzing about.

BARK RUBBING

This tree bark is looking a little bare ... Give it some tough texture using any method you like.

A LUMBERJACK'S LIFE

This woodcutter is ready to get chopping! But they need a supply of logs. Draw in a fresh batch!

BLOWING A GALE

This sailboat could use some fortune in its sails. Draw a hearty gust of wind sending it off to sea, and add some waves, if you like.

GIRAFFIC DESIGN

Fill in the pattern on this giraffe's neck. Maybe you can make it look like a new breed entirely?

PUT A RING ON IT

Design an engagement ring. Is it one you'd like to give or receive, or are you making it for someone else?

TASTES FROM THE TROPICS

Fill this bowl with tropical fruit you'd like to try out, or fruit you already know you enjoy.

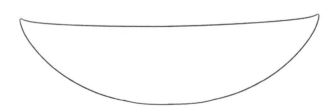

AND THE WINNERS ARE . . .

Design some doodle trophies to award your friends. What titles have they won?

CROCODILE SMILE

This jolly croc would be even happier with a proper set of teeth! Play doodle dentist and draw some in.

STRIPED SWEETS

Pile as many striped candies into this jar as you like. Just don't eat them all at once.

FAST FOOTWORK

Doodle lots of motion lines to show these tap-dancers with their legs in a blur!

GREEN MEANS GO!

Draw in the cloud of dirt this speedy bike is kicking up at the start of the race.

TEMPORARY TATTOO

Try your hand at some tattooing on these hands here.

FIRE SPRITES

This fire spirit could use some extra sizzle and spark. Finish doodling their spritely form, then try adding some fiery friends.

WADING BIRDS

Model some new legs so these fabulous flamingos can strut their stuff, and add more birds, if you want!

THE COMPASS ROSE

Which direction would you like to travel in? Think about someone or someplace you'd like to visit and doodle a decorative letter for each point of the compass.

ROOMS WITH A VIEW

Add windows to these skyscrapers. Are these offices, apartments, or something else entirely?

TOMORROW IS ANOTHER DAY

Draw more clouds and some sunbeams, if you like, as you think of ways you can make tomorrow even better than today.

TICK TOCK

Draw a pendulum swinging from the bottom of this clock. You could make something fancy, or try drawing it in a way that implies a sense of time slowing down.

BUGGY BITES

What bugs is this hungry frog craving? Draw some buzzing insects for it to catch!

SCALY SNAKES

Decorate the backs of the snakes. Can you create a theme that links them together?

GO FLY A KITE

Design some different kites gliding together on a breeze.

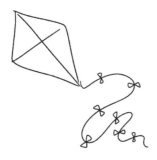

BOUNCING BALL

Add movement lines and obstacles to trace the path this ball has taken down these stairs. Did it take an unexpected turn anywhere?

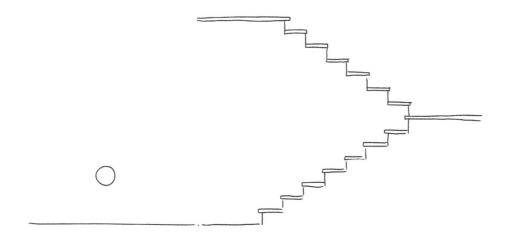

SPEEDY SPAGHETTI

Add splashes of sauce, and maybe a bit of leftover spaghetti, to this messy customer.

MUSIC FROM THE STREETS

Draw musical notes wafting up from the street musician to the people listening on their balcony. What genre of song is it?

FLYING MACHINE

Design a flying machine that will let this pilot soar through the clouds!

BRIDGING THE GAP

Draw a bridge to help these hikers cross the ravine. Even if it's made of doodles, try to make it sturdy for them!

100 STEPS

Draw some legs for this wandering bathtub! Is it in a hurry to go somewhere or just taking a leisurely stroll?

A KISS GOODBYE

Help these smooching sweethearts keep the fire alive by drawing some extra love. Include Xs, hearts, and more to make it spicy.

KING OF THE JUNGLE

Draw in some intense lines and effects to make this lion's roar command everyone's attention.

TREAD SOFTLY!

Draw some cracks appearing in the ice under the feet of these poor ice fishers.

CHOCOLATE CHIPS

Cover these giant cookies with plenty of chocolate chips. Not "some," but "plenty"!

CHERRY BLOSSOM

Add some cute blossoms to this cherry blossom tree, and feel free to have some petals floating around.

A HEAVY LOAD

The weight of a doodle can be a lot to bear! Draw in whatever this crane is struggling to lift.

FIGHTING FIRE

These firefighters need a fresh supply of scribbled-in water to douse some dangerous flames!

A SPECIAL TIME

Add hands to these clocks to show your favorite time of day, then jot down why that time is special to you.

CURLY COATS

Add curly hairs to these furry coats. You could go natural or pamper these pups with something fashionable.

KITTEN KIBBLE

Decorate each of these bowls for a set of kittens. Feel free to add names for these cats, if you like!

SUPER SWEATER

Put a little love into doodling patterns onto this knitted sweater.

FLOATING LANTERNS

Doodle up a bunch of lanterns soaring into the evening sky.

CRASH, BANG, RATTLE!

Design a noisy toy for this baby to cause a racket with, and add some effects to show what sort of sound it makes.

HEAR, HARE, HERE!

Add ears to these bunnies. Try differentiating them from one another. What names would you give them?

QUACK, QUACK, QUICK!

Complete this line of ducklings so they're following their mother.

A PAINTED PIRATE

Cover this pirate's arms from top to bottom in a variety of tattoos!

SKY DIVER

This sky diver needs a new parachute! Doodle one in, and try to spruce it up for a fancy flight.

LIGHTING THE WAY

Help make this path welcoming and safe by adding flames to these torches.

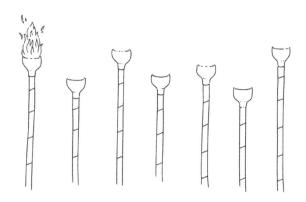

MY FAVORITE!

Can you pin down your favorite meal when you eat out? Dish up a helping of it here, along with a drink to go with it.

TOOTHY GRINS

These walruses are in the mood for a makeover. Spare no expense, and give them glorious new tusks.

CATCHING SOME ZZZZZ'S

Adding in some big Zs drifting from this snoring giant should help warn any passersby to be cautious and quiet.

SUPER FRY GUY

Add some eggs to this frying pan, cooking them up in your favorite style. Feel free to include some extra ingredients if you're really hungry.

MULTI-BALL

Fling tennis balls all over this court! Don't forget to add shadows on the ground for each one you draw.

MAGIC BEANS

Have you heard stories of giant beanstalks growing from magic beans? Try doodling a few as they begin to sprout from the earth.

GELLIN', VIBIN'

Add trailing tentacles to this swarm of relaxed jellyfish.

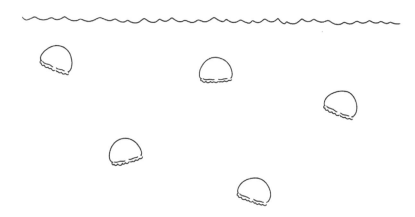

I MUSTN'T FORGET

Draw a knot in this string for each thing you'd like to remember to do today. You could also write a list to make sure you remember.

HAPPY MEMORIES

Recall your favorite memories. Add a different, special bead to this necklace to represent each one.

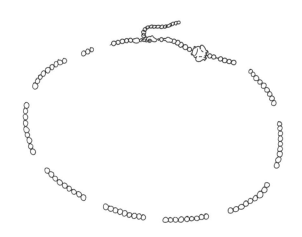

A BIT OF A PRICKLE

Doodle in all the spines on this portly porcupine.

ZIPPING AROUND

Think about performing actions at high speed, and fill this space with marks that represent dynamism and acceleration.

PANCAKE STACK

Your best friends are coming over for breakfast! Add a couple of pancakes (or more!) to the stack for each of them.

TOUCHDOWN!

They might go all the way . . . But what's this? That's not a football they're catching! Draw something unexpected.

PONY AND . . . ?

What are these two ponies pulling? Is it a passenger carriage, produce cart, or something unexpected?

SPIRALS, ROUND AND ROUND

Doodle spirals all around this space. Do you start from the outside or the inside?

LET'S GO SURFING NOW!

Add a "totally tubular" design to the side of this surfboard!

KITTEN TOYS

Doodle in balls of string for these playful kittens to go wild with.

AHOY!

Put up the sails and fill them with some wind. It's time to embark!

USE YOUR NOODLE

Order up! Draw noodles in these bowls until there's enough to go around.

LUCKY FOR SOME

Stock up on lucky horseshoes! Draw in as many as you think you'll need to keep your luck running through the week.

KARAOKE

Doodle in microphones, and between them, write lines from a song you love to sing.

SUMMER SUITS

Add an attractive design or a pattern to these swimwear.

BUTTON UP

See how many different shapes and sizes of buttons you can think of as you draw a bunch here.

PIPING HOT

Hot steam is rising, but from what? Is it a meal, a drink, or something else? Doodle in something warm and comforting to you.

SPEEDWAY

Draw in a fast, furious smoke cloud rising from this racing car's screeching tires.

MANICURED

Someone's here for a nail makeover, and they need your expertise designing their new look!

COSTUME MIX-UP

These costumed partygoers have gotten their hats mixed up! Finish this drawing by adding the right hats to the wrong heads.

SUMMER FRUITS

Stock up on fresh, natural treats by doodling in strawberries and raspberries aplenty.

TO INFINITY

Draw figure eights all across this space without taking your pen off the page.

DON'T BOTTLE IT UP

Doodle in different bottle shapes here. Throw in some jars, if you like.
Is there anything in them?

GLORIOUS MUD!

Doodle the muddy puddles that these kids are playing in, but get
ready for a bath when you come back inside.

RULER OF THE CASTLE

Add more towers, turrets, and flags to this castle so it's fit for royalty.

FOOD FIGHT!

Join in by doodling foods flying through the air. Serve up an entire menu!

SANDS OF TIME

Show these hourglasses with different amounts of sand slipping away.

ANTLERS

Draw sets of antlers on these moose, and feel free to decorate them.

SHAKEN BUT NOT STIRRED

Add umbrellas, fruit slices, and other flourishes to these cocktail drinks.

HARPING ON YOU

Get this harpist ready for their performance by adding the strings to their instrument and touching up their stage for an elegant show.

HELLO, MY NAME IS:

Doodle decorative letters that spell out your name and express something about you.

SOMEONE'S BEEN DOODLING MY PORRIDGE!

Serve up some bowls of porridge that are just right for these three hungry bears.

WHAT GOES AROUND

Write the names of some people you like, then draw circles around them and decorate those circles to match each person.

IN THE FOREST OF THE NIGHT

This jungle cat is stalking through the night, but it needs a set of stripes to blend in with its surroundings!

HIP HIP HOORAY!

Draw some radiant hats so these excited suns can celebrate in interstellar fashion.

COMIC BOOK TEXT

Doodle these five words in a style that emphasizes their meaning on the page of a comic book: BANG!, CRASH!, SHIVER!, ZIP!, SHATTER! Here's an example to get you started: KABOOOOM!

SCROLL TO THE BOTTOM

Draw up some scrolls and add names of people you know with messages to them.

SANDCASTLE

Design your ultimate sandcastle. Make it huge, but stick to materials from the beach like seaweed and shells.

TIE A RIBBON

Doodle some ribbons wrapped around this old tree.

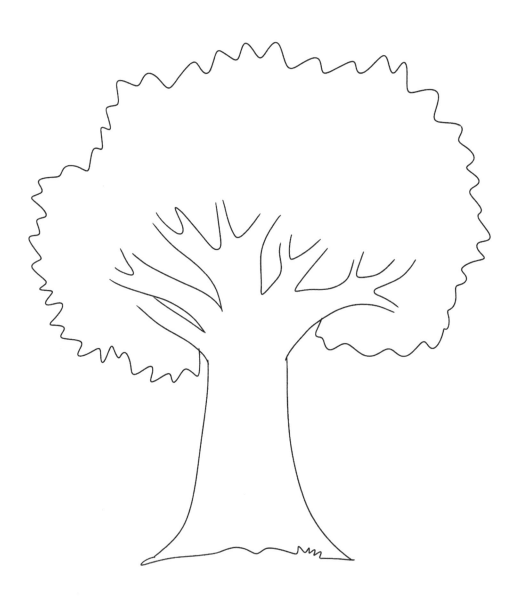

IT'S A TWISTER!

The forecast calls for high winds. Doodle up a huge tornado storming across the landscape. What has it picked up?

LOOKING SHARP

Draw up some different bow ties for a big convention! Give each one a distinct pattern or style.

A LITTLE MORE BASS

Draw vibrations coming from these bass speakers that really add weight to the deep sounds they're making. Don't forget to add another set of speakers to the other side.

PRETTY BLIZZARD

They say every snowflake is unique. Try drawing a bunch of stylized snowflakes that are different from one another.

"SHEAR" ARTISTRY

This gardener has finished their masterpiece. Draw in the bushy hedge sculpture they've created.

FLYING HIGH

Draw in the spinning rotors of this helicopter. Give the lines some oomph to really show their energy and speed.

Go, Go, Go!

Draw in the obstacles a daring racer would have to speed through, over, or around! Is there anything on the track that shouldn't be there?

SEE HOW THEY RUN

These mice have misplaced their tails. Give them some new ones so you can tell each mouse apart.

COME ON, DIVE IN!

Draw some inflatables floating in this pool to make it look inviting. They could look like a swan, flamingo, or maybe a giraffe or elephant!

SPOOK-TASTIC!

Give this friendly spirit some paranormal pals by adding more goofy ghosts to the scene.

STRIKE?

Draw in the bowling pins with a design that matches a special bowling alley theme.

THE MOUNTAIN WAKES

This volcano is no longer dormant! Try capturing the moment on paper by drawing a freeze-frame of the eruption.

WHO'S FASTER?

Add clouds of dust, footprints, and a track to show that this tortoise and hare are racing. Who will win?

ORANGES AND LEMONS

Doodle fresh-looking citrus fruit all over this space, and try not to get any juice in your eye!

MOUNTAINEERING

Doodle in a tricky mountain wall for these climbers! It could have difficult terrain and ledges, or perhaps it looks more like a rock-climbing wall in a gym.

FANCY FRAME

Doodle an extra special frame around this work of art.

BUT IS IT ART?

Draw a strange piece of modern sculpture. Try shading it in to make it feel like a 3-D object.

EBBS AND FLOWS

Doodle lines and dashes to show this river flowing. Add some whirlpools at its edges.

A WRENCH IN THINGS

Try doodling as many different workshop tools as you can think of. Take a look at some references, if you want.

FOREVER FLOWING

Design a new water fountain for a park, and show how the water would flow around or through it. Is it built for admiring or for playing in?

HERE'S LOOKING AT YOU, KID!

Doodle in a wall of eyeballs of any kind you like—or don't like—staring back at you.

RING OUT THE BELLS

Doodle in different kinds of bells as you ring in new beginnings!

RESOURCES

If this book has piqued your interest and you would like to delve deeper into the worlds of doodling, art, and/or mindfulness, these websites are a good place to start. Ideally, you should get out and see as many galleries and exhibitions as you can.

Connect with artists and galleries on Pinterest, Behance, and Instagram:

 Pinterest.com

 Behance.net

 Instagram.com

Exploring Artists Through Their Sketchbooks:

 EtchrLab.com/blogs/news/exploring-sketchbooks

The Sketchbook Project:

 SketchbookProject.com

Artists Who Use Their Sketchbook as Handheld Galleries:

 Scene360.com/art/101195/sketchbook-artists

an Artist" Podcast:

 Podcast.com

For art materials at a fair price, check out:

IlloSketchbook.com/shop

Inktober is a great challenge with a supportive community, encouraging participants to create 31 drawings over the 31 days of October:

Inktober.com